7 Train

Jake Wallace is a native New Yorker and has been photographing street textures, signage and urban architecture for more than 15 years. He combines his passion for design, typography, painting, screen printing, and graffiti to create unique mixed media works inspired by the urban and industrial landscapes of his hometown, NYC. Follow Jake on Instagram: *@jakewallacenyc_art*

Artwork:
7 Train © Jake Wallace

Published by teNeues Publishing Company
© teNeues Publishing Company

www.teneues.nyc